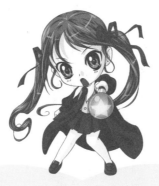

THIS WORKBOOK BELONGS TO:

D1122477

POTTER STYLE

Text and artwork from the book *Manga for the Beginner Chibis: Everything You Need to Start Drawing the Super-Cute Characters of Japanese Comics by Christopher Hart.*
Copyright © 2010 by Star Fire LLC. Published by Watson-Guptill Publications, an imprint of the Crown Publishing Group, a division of Random House, Inc., New York.

www.crownpublishing.com | www.clarksonpotter.com

ISBN 978-0-307-72004-7

PRINTED IN CHINA

Design by Dominika Dmytrowski

Contributing artists: Denise Akemi,
Diana Devora, Romulo Fajardo,
Aurora Garcia, Christopher Hart, Agnes Lim,
Morgan Long, Chihiro Milley,
Ecky Oesjadi, Adetyar Rakhman,
Yuu Sanau, Nao Yazawa

10 9 8 7 6 5 4 3 2

FIRST EDITION

CHIBI BASICS

Chibi proportions are different from those of the rest of the characters in the manga universe. Certain aspects have to be emphasized and exaggerated to make them ultra-cute. We're going to start off by focusing on the large head shape, the tiny body, and those giant eyes. Keep your chibi simple; don't overcomplicate the face. The fewer lines, the better!

CHIBI PROPORTIONS

Chibis typically have giant heads on small, childlike bodies and round little hands and feet. The most popular proportion for drawing chibis is about three head lengths tall. That means that if you were to stack three chibi heads one on top of the next, it would equal the chibi character's total height.

However, three heads is by no means the only chibi proportion that manga artists follow. In fact, some manga artists specialize in highly stylized, super-exaggerated chibis, which are just two heads tall and excruciatingly adorable!

Other, even more exaggerated chibis have heads that are twice as big as their bodies. You can draw your chibi any size you want; however, when you start to make them taller than three heads, they begin to look like normal-size people and leave the realm of chibis. So be sure to keep their heads large in proportion to their bodies.

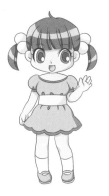

Average chibi (three heads tall)

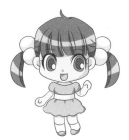

Super-exaggerated (two heads tall)

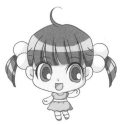
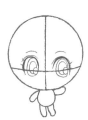

Extreme chibi (head twice as tall as body)

THE CHIBI HEAD ▶ Girl, Front View

Chibis are among the easiest faces to draw in manga, because the features are so basic. The noses are all but dots, and the mouths are simple. The eyes take a bit of work—and fill up most of the face. The eyes, like all of the features, are always placed low on the face. The face is round, without any hint of angularity. The temptation is to start off with those great big eyes, but it works best to begin with the outline of the face and then work your way to the features.

1 Chibi eye line is very low on face.

Chibis have small noses and mouths. Some have no nose at all!

2 Dark, thick eyelids all the way around

Giant eyeballs drawn as ovals

3

FINAL

GET STARTED!

Use this space to work on your own chibi girl face, seen from the front.

THE CHIBI HEAD ▸ Girl, Side View

In the side view, a chibi face looks quite young because of the deeply curved, sweeping line that makes up the forehead and bridge of the nose. Be sure to exaggerate this part. From the tip of the nose to the chin, the face travels steeply back along a diagonal, as indicated by the blue arrow below. The nose is small and upturned.

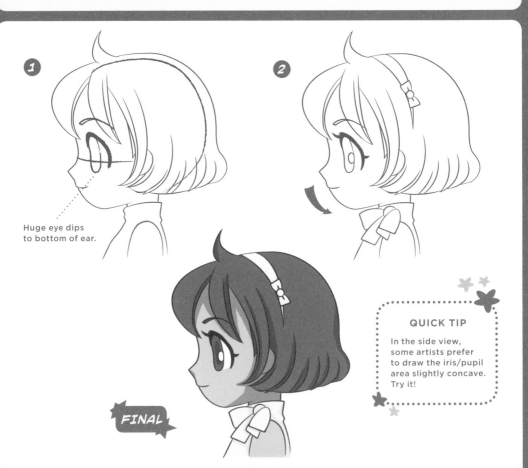

Huge eye dips to bottom of ear.

FINAL

QUICK TIP

In the side view, some artists prefer to draw the iris/pupil area slightly concave. Try it!

Use this space to draw your own chibi girl face,
seen from the side.

THE CHIBI HEAD ▸ Boy, Front View

Boys' and girls' head shapes are the same—it's the eyes (no eyelashes here) and hairstyles that are different (plus, the boys' eyebrows are a bit thicker). Note the standard chibi hallmarks: the huge eyes set low and wide on the head, the mouth set even lower, the hair flopping down over the fore-head, and the hardly even noticeable neck.

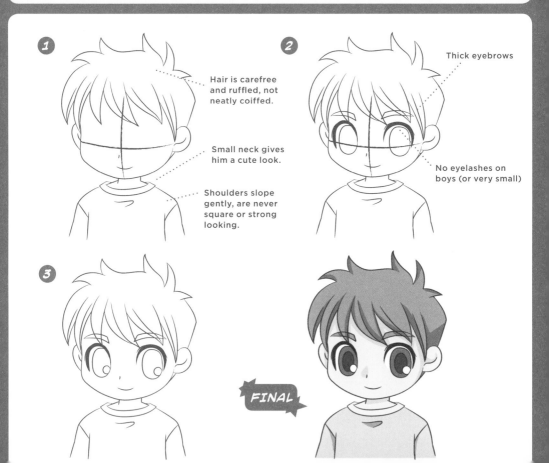

1

Hair is carefree and ruffled, not neatly coiffed.

Small neck gives him a cute look.

Shoulders slope gently, are never square or strong looking.

2

Thick eyebrows

No eyelashes on boys (or very small)

3

FINAL

YOUR TURN!

Use the guides to create your own chibi boy face, viewed from the front.

THE CHIBI HEAD — Boy, Profile

In profile, faces look quite young because of the deeply curved, sweeping line that makes up the forehead and the bridge of the nose. It works the same way on boys as on girls.

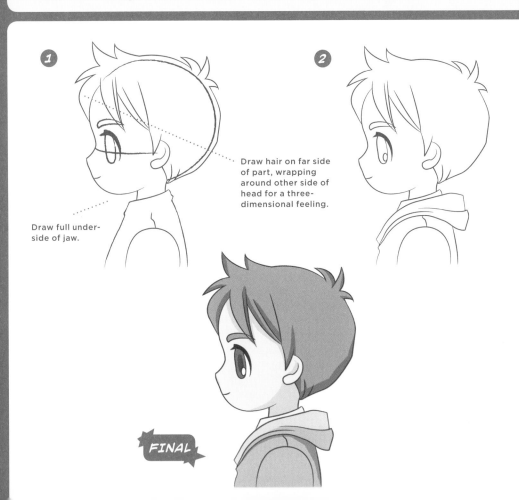

1

Draw hair on far side of part, wrapping around other side of head for a three-dimensional feeling.

Draw full underside of jaw.

2

FINAL

YOUR TURN!

Use the guides to create your own chibi boy face,
viewed from the side.

THE CHIBI HEAD ▷ Hair Shine

The hair shine—that white area—gives manga hair its look of luster. In this style, the shine is drawn as a wave, which is soft and feminine.

A scrunchie or bow appears at crest of head, peeking out just enough to be seen.

Bangs start above forehead.

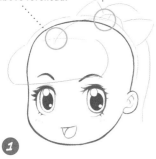

Bangs break apart into uneven strands to add variety.

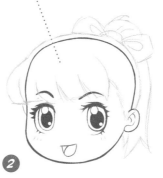

Alternate long strands with short ones.

Two lines create a wavy highlight.

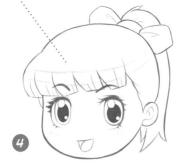

Shade in all hair except shine with pencil, or add gray tone or color.

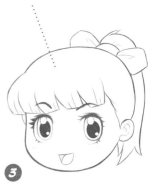

FINAL

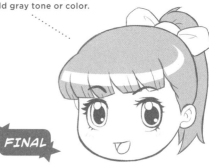

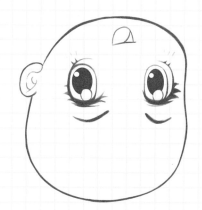
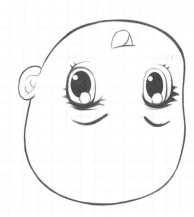
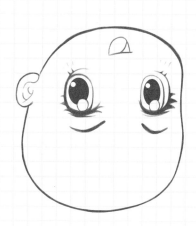
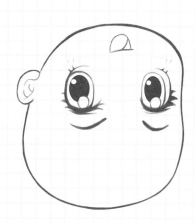

Using the steps above, add the hair and hair shine to the blank heads.

ADD YOUR OWN!

THE CHIBI HEAD > Everyone Can Be Chibified

An uncontrollable surge of emotions triggers manga characters to suddenly "turn chibi." They exhibit a broad chibi expression for an instant, then snap back to their normal selves just as quickly. Strike the word *subtlety* from your vocabulary when drawing ordinary-expressions-turned-chibi. In fact, the only way to really tell just how over the top to take these expressions is to compare them to regular manga expressions. Chibi expressions use lots of special effects to enhance their crazy look.

NORMAL MANGA WORRIED

Regular manga styles show a lot of whites in the eyes and a small, round mouth.

CHIBI WORRIED

Her eyes go huge, her mouth goes wide, and her hair goes completely nuts! Put both sets of knuckles in the mouth.

NORMAL MANGA EXHAUSTED

Here's the classic look of fatigue: one leg down, the other leg up. He rests his elbow on his knee. His mouth is opened slightly for him to suck some air. His head hangs low on the shoulders.

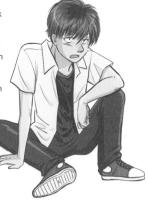

CHIBI EXHAUSTED

This chibi can't pose his body in the same way as the teenage boy, because he's too short and chunky to do all that bending! So he sits with his legs straight ahead, knees locked, and both hands on the ground. Instead of taking just a few breaths, he is in a full-out pant, with tongue out and sweat flying off him. Notice the errant strands of hair about his head.

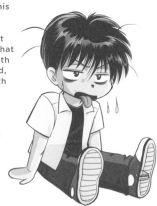

CHIBIFY!

Using the examples, try re-creating these extreme chibi emotions.

CONCERNED

Her eyes are wide, and her mouth is just a squiggly noodle. Her blush marks mimic tears.

EMBARRASSED

The blush streaks extend across the entire length of the face. Her huge mouth dips below the face's lower outline.

CHIBIFY!

Using the examples, try re-creating these extreme chibi emotions.

PAIN

The entire face has squashed down, and the mouth breaks through the outline of the face.

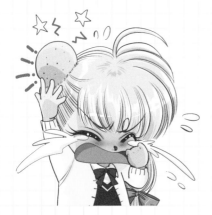

UPSET

Everything is oversized—big hair, gritted teeth, eyes, and blush marks.

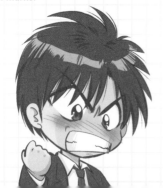

Big eyes with beady little pupils. The mouth is at the very bottom of the face.

Wide face and smile. Dots are placed under her eyes instead of eyelashes.

CHIBIFY!

Using the examples, try re-creating these extreme chibi emotions.

Using the examples, try re-creating these extreme chibi emotions.

HUNGRY

Cross the eyes to give him a crazy look.

EXHAUSTED

This chibi is in a full-out pant. Notice the errant strands of hair about his head.

CHIBIFY!

Using the examples, try re-creating these extreme chibi emotions.

DISGUSTED

The hair gets a little squirrelly, and the mouth almost runs off the face.

WORRIED

Her eyes go huge, and her hair goes completely nuts!

THE CHIBI BODY — Girl, Front

The torso of a chibi is one basic shape. Many chibis show no neck; instead, the head attaches directly to the shoulders. In addition, the chibi head is much wider than the entire height of body is tall. The eyes are spaced far apart, making full use of the head's considerable width. Chibis never have long legs, always short and thick ones. Sometimes the legs get widest at the bottom, toward the feet, but that's a stylistic choice.

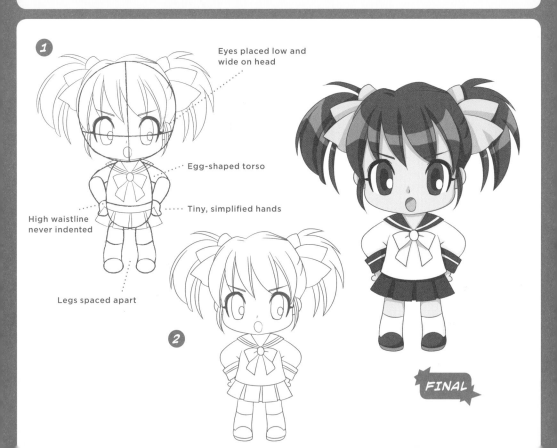

1

Eyes placed low and wide on head

Egg-shaped torso

Tiny, simplified hands

High waistline never indented

Legs spaced apart

2

FINAL

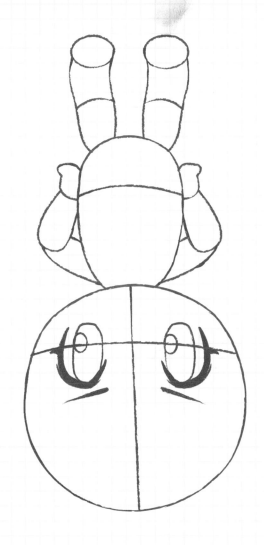

Use the guide below as a basic outline to create your adorable
preppy schoolgirl in front view.

YOUR TURN!

THE CHIBI BODY ▷ Girl, Side View

In a side view of the body, you can hide the rear leg behind the front one, but I wouldn't recommend it. When two limbs are positioned exactly the same way, parallel to each other, doing the same thing, it's called "twinning." A twinning character looks stiff and immobile, like a statue. By making one knee bent and keeping the other straight, you add variety to the pose and make it more interesting. To add more energy to the pose, raise one of the arms away from the body.

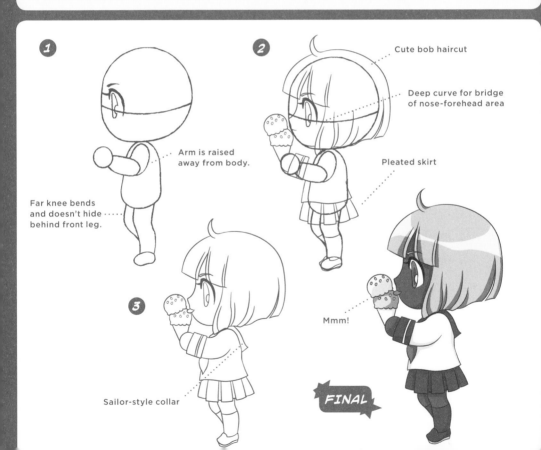

1

Arm is raised away from body.

Far knee bends and doesn't hide behind front leg.

2

Cute bob haircut

Deep curve for bridge of nose-forehead area

Pleated skirt

3

Sailor-style collar

Mmm!

FINAL

GET STARTED!

Use this space to work on your own girl, viewed from the side.

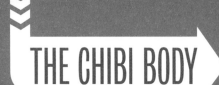

THE CHIBI BODY ▷ Girl, Standing, ¾ View

The ¾ view is the most frequently used pose. It's a natural angle, easy on the reader's eyes. It reveals more of the character than a side view and shows more depth than a front view. For the artist, however, it takes a little getting used to because it involves a little bit of perspective. But once you get the hang of it, you'll always be able to do it.

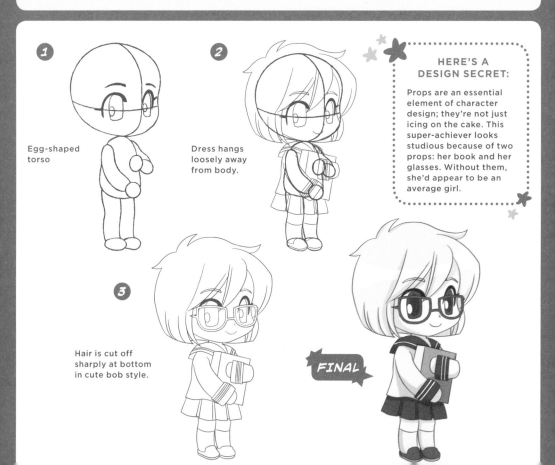

1 Egg-shaped torso

2 Dress hangs loosely away from body.

3 Hair is cut off sharply at bottom in cute bob style.

HERE'S A DESIGN SECRET:

Props are an essential element of character design; they're not just icing on the cake. This super-achiever looks studious because of two props: her book and her glasses. Without them, she'd appear to be an average girl.

FINAL

THE CHIBI BODY ▸ Girl, Walking, ¾ View

Notice the center guideline drawn down the middle of the head and torso. It makes the head and torso look solid and three-dimensional. Try adding a center line as you draw your character; it will help you to translate what you're visualizing onto the page.

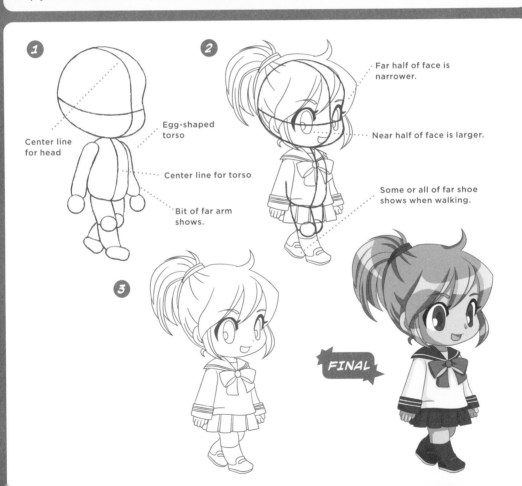

1

Center line for head

Egg-shaped torso

Center line for torso

Bit of far arm shows.

2

Far half of face is narrower.

Near half of face is larger.

Some or all of far shoe shows when walking.

3

FINAL

TRY IT OUT!

Use this space to work on your own walking girl in $^3/_4$ view.

THE CHIBI BODY ▸ Boy, Front View

This casual kid wears a knockabout outfit for playing with his buddies. The boy chibi body has the same basic construction as the girl's but his shoulders are a bit more built up, and so are his arms. Still, he's no bodybuilder! The main differences between him and the girl are his costume and hairstyle.

1

Extra-wide head

He has just a smidgeon of shoulder muscles.

He'll never be a track star with those short legs.

Basic egg-shaped torso

Lots of hair

Loose or oversize clothing is always funny on chibis.

2

FINAL

Don't be afraid to give chibis lots of hair. Yes, their heads are already big, but the added size makes them funnier and cuter!

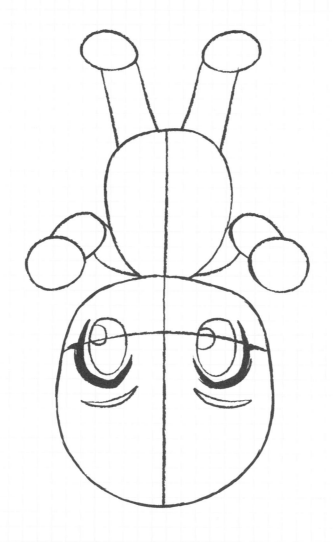

Use the guide below as a basic outline to create your chubby,
cute chibi boy, front view.

YOUR TURN!

THE CHIBI BODY ▶ Boy, Side View

Once again, we want to avoid twinning the pose. We've lifted up one arm, moving it outside the body outline. Now the pose has some life to it. Note that occasionally you can break the twinning rule with a front view of a standing chubby, cute character, who looks appealing with two stiff legs side by side.

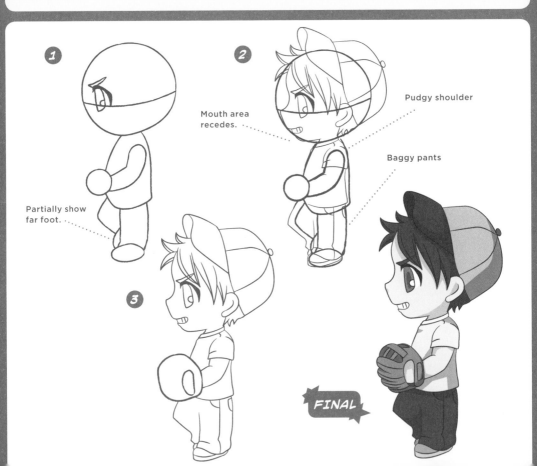

Mouth area recedes.

Pudgy shoulder

Baggy pants

Partially show far foot.

FINAL

TRY IT OUT!

Use the illustrations above to create your own chibi boy,
viewed from the side.

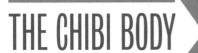

THE CHIBI BODY ▷ Boy, Standing, ¾ View

To make a character look round in the ¾ view, indicate the far ear, on the other side of the head, as well as the far arm. Some beginning artists leave them out, and the result is a flat-looking image. Another thing to consider is the size of the chibi forehead: it's humongous! Cover it with hair that brushes over the eyebrows in bangs or is raked to the side.

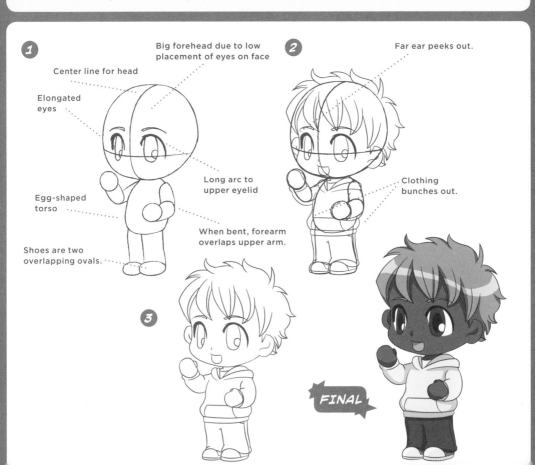

1

Center line for head

Big forehead due to low placement of eyes on face

Elongated eyes

Egg-shaped torso

Long arc to upper eyelid

Shoes are two overlapping ovals.

When bent, forearm overlaps upper arm.

2

Far ear peeks out.

Clothing bunches out.

3

FINAL

YOUR TURN!

Use the illustrations above to create your own chibi boy standing, in ¾ view.

THE CHIBI BODY > Boy, Walking, ¾ View

Again, to make a character look three-dimensional, indicate the far ear and the far arm. In this case, show a little bit of the heel of the far foot as it rises up off the ground. Also, make sure that the straps of the backpack loop over and under the shoulders. Even though chibis are small, you still have to use logic in designing a character, its wardrobe, and the accessories.

Far arm shows.

Far ear peeks out.

Part of far shoe shows.

FINAL

TRY IT OUT!

Using the illustrations above, create your own walking chibi boy, in ¾ view.

THE CHIBI BODY ▶ Hands and Gestures

I don't have to tell you that drawing hands can be a challenge. The good news is that drawing chibi hands is easy! That's because they rarely show the fingers. Their small, round hands are mostly drawn like mittens. And in the few instances when individual fingers are shown, they're depicted as short and cute, without any joints, knuckles, or fingernails. Even at their most defined, chibi hands look like puffy ski gloves.

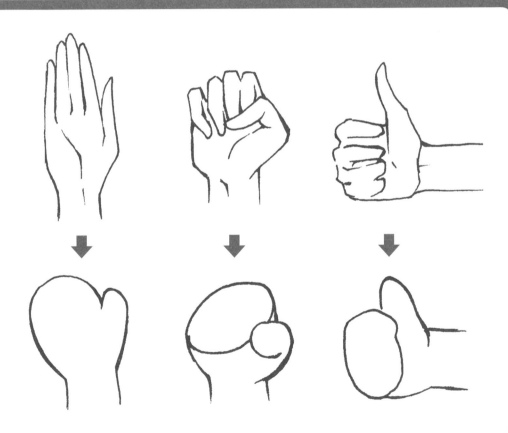

SKETCH IT!

Even though their hands are so basic, you don't want to lose
any expressiveness. Try drawing a few of these gestures.

Here are a few more examples for you to look at.

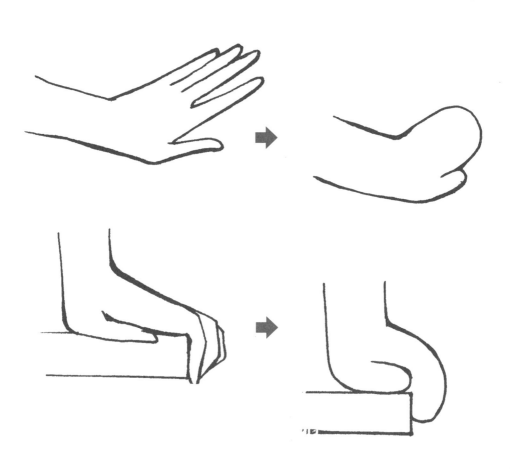

SKETCH IT!

Even though their hands are so basic, you don't want to lose any expressiveness. Try drawing a few of these gestures.

CHIBI TRICKS ▶ Making Clothes Look Real: Shirts

Whenever a character moves or bends, the body pulls and tugs against clothing. This results in folds and creases. Wrinkling at specific points in the fabric makes clothing look real and flexible. You need to figure out where the clothing should be smooth. The areas where the clothing *presses down* on the body should be *free* of wrinkles and creases. Creases generally radiate outward from those places where the surface of the clothes is in close contact with the surface of the body.

FLAT SURFACE

On a table, the top of the tablecloth is free of wrinkles and creases, because it's pressed tightly against the surface of the table underneath it.

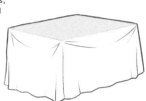

ROUND SURFACE

On a round surface, the uppermost rounded area is smooth. The wrinkles and folds occur once the cloth falls off from the rounded area.

TIGHT SHIRT

A tight-fitting shirt will show fewer wrinkles than a looser garment.

LOOSE SHIRT

When there's a lot of room in a garment, the material will bunch up, resulting in more creases. Creases that form on the torso are generally drawn across the body.

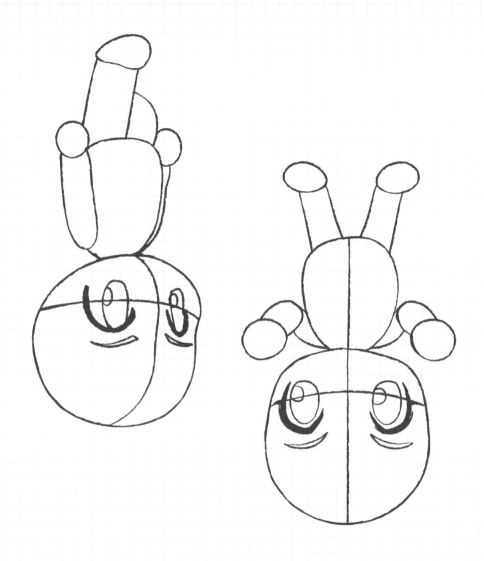

Using the outlines below, try adding different types of shirts to the chibis.

Making Clothes Look Real: Skirts

Just because a skirt is short doesn't mean it's smooth. A skirt with a band around the waist will have crease marks on the hips. The waistband is not drawn across the body as a straight line. It's drawn on a curve, because it travels around the body, and the body is round.

LOOSE SKIRT

On a loose skirt, creases begin at the waistband and angle inward as they travel down the garment.

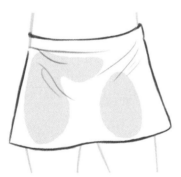

TIGHT SKIRT

On a tight skirt, the major creases appear in the middle of the skirt.

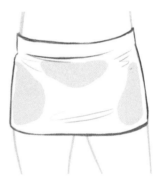

THE PLEATED SKIRT

The pleated skirt is the most popular style for school uniforms. It flares out more than the others and shows no creases besides the pleats.

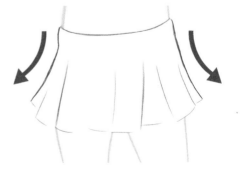

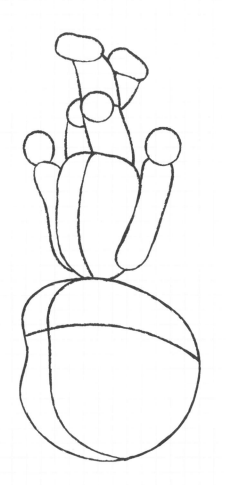

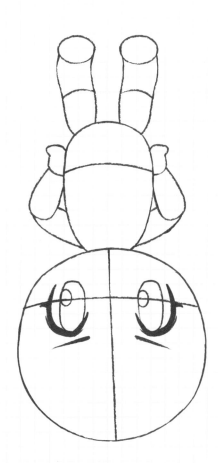

Using the outlines below, try adding different types of skirts to the chibis.

TRACE IT!

Boy chibis are rough on clothes. They tug and pull and twist and yank them. This results in lots of folds and creases. If you know how to make correct folds, you won't have to use as many to make boy clothes look convincing. Too many folds make clothes look old and wrinkled instead of dynamic.

STRAIGHT ARM

This fold occurs when the fabric is straight and begins to droop due to gravity. If you don't show this effect, the clothing will look stiff.

RIGHT ANGLE

Bending the arm at a right angle produces a small pocket in the elbow that looks like a little loop.

45-DEGREE ANGLE

When the fabric is really squeezed, three interlacing lines are used to create the appearance of a tightened, interlacing fold.

BENDING WITH PULLING

When the arm bends and also pulls, a lot of little tugging folds radiate outward from the crook of the elbow or wherever the origin of the fold is (such as the knee).

SKETCH IT!

Try drawing arms and sleeves in the space below. Be sure to try out different styles and angles.

CHIBI TRICKS ▶ Adding Pattern

Simple designs work best, because they're easier to read than splashy ones—especially when figures are reduced all the way down to chibi size. If you're not working in color, alternate your black and white areas with grays to make the garment stand out. Placing white beside white or black beside black blends the tones together and causes the outfit to lose definition.

1

Start with a simple top that flares at the bottom.

2

Sketch in two guidelines for the trim, one at the top and one at the bottom.

3

A simple, repeating pattern in the trim is pleasing to the eye.

4

A ribbon is a nice touch and adds a bit of decoration.

5

For a vertical stripe pattern, draw vertical lines that indent slightly at the waist (all chibis have a high waistline).

6

Go back and add a thick black outline to the trim and straps. This will make the outfit stand out.

7

Shade alternate stripes in the top.

8

Add a black skirt to tie in with the black trim and straps. The pleats are indicated by white lines inside the black skirt.

CHIBI TRICKS ▶ Shoes

Chibi shoes are clunky. They look somewhat oversized for the character. Even if they have style, they're too big to be trendy, but that's part of the fun. How hip can a chibi really be? Their feet are too big to look slick! Whether the shoes are boots, high heels, or sporty shoes, keep them simple, and trust that your character's truncated proportions will make them funny. Oversized shoes, sneakers, and sandals will make the legs appear even shorter—a comical look. Here are a few examples.

SKETCH IT!

Try drawing shoes in the space below. Be sure to try out different styles and angles.

CHIBI CHARACTERS > Samurai Bad Girl

In manga, bad samurai are just as widespread as good samurai. The bad attitude is funnier on chibi characters, though, because it stuffs so much intensity into a small package. Note how the upper eyelids press down on her eyes; it's not just the eyebrows that make the frown. For the pose, the legs face forward, but the body twists into a ¾ turn, coiling up as she pulls her blade from its scabbard.

1

Far arm is blocked from view.

Arm reaches diagonally across body to grab sword handle.

Shoulder rises a touch above face.

FINAL

Using the outline below as a guide, create your own kick-butt
samurai bad girl.

CHIBI CHARACTERS ▷ Vampire Gal

Vampire gals are almost always drawn with long, flowing hair and wearing a black skirt with high heels. For a more Victorian look, you'll sometimes see a long dress with a tattered hemline. A robe or a cape can also be a featured accessory.

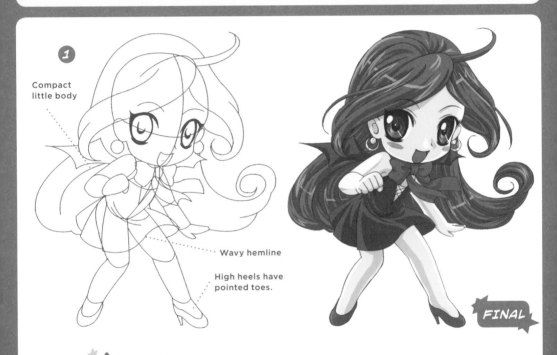

1

Compact little body

Wavy hemline

High heels have pointed toes.

FINAL

DRAMATIC SKIRTS

The reason the skirt looks so effectively dramatic here is that it has several different forces working on it at the same time (indicated by the arrows). These cause it to billow out and fold dramatically.

Using the outline below as a guide, create your own vampire gal.

CHIBI CHARACTERS > Sad Sack Prisoner

Although nowadays most prisoners wear orange jumpsuits, the cartoon version still wears the stereotypical black and white, long-sleeved costume with a ball and chain attached to the ankle. It's a funny look, instantly recognizable, and has become a convention in comics of all kinds.

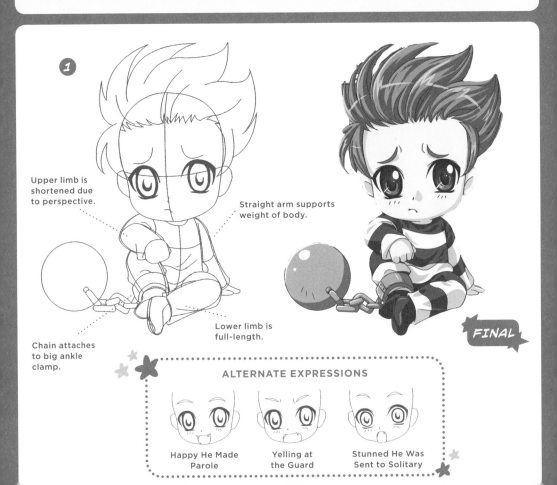

1

Upper limb is shortened due to perspective.

Straight arm supports weight of body.

Chain attaches to big ankle clamp.

Lower limb is full-length.

FINAL

ALTERNATE EXPRESSIONS

Happy He Made Parole

Yelling at the Guard

Stunned He Was Sent to Solitary

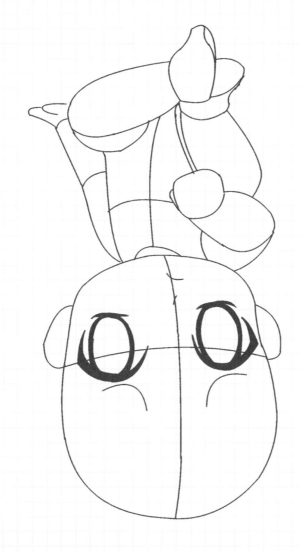

CHIBI CHARACTERS ▶ Goth Boy

Goths love to wear trench coats, boots, and gloves—anything to shield them from the sunlight. It makes us wonder if he is more than merely a goth... But if he were a vampire, then we'd have to eliminate the cross on the bottom of his coat. Maybe he's just plain spooky.

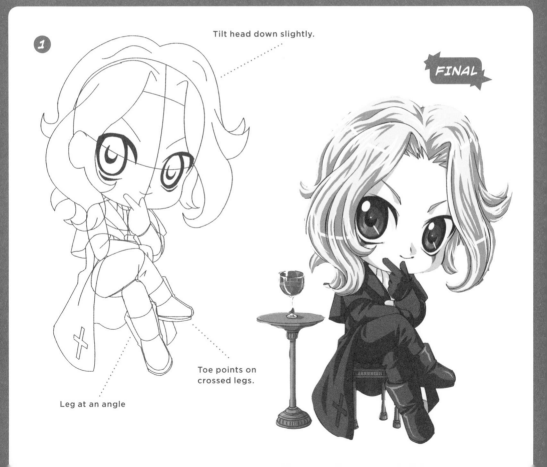

Tilt head down slightly.

1

FINAL

Toe points on crossed legs.

Leg at an angle

Using the outline below as a guide, create your own spooky
goth boy.

CHIBI CHARACTERS > Mad Scientist

Mad scientists—even budding ones—always wear lab coats and glasses. This one has wild, crazy-professor-type hair. Mad scientists are made for chibis, because they're all brain and no body—the perfect chibi proportions.

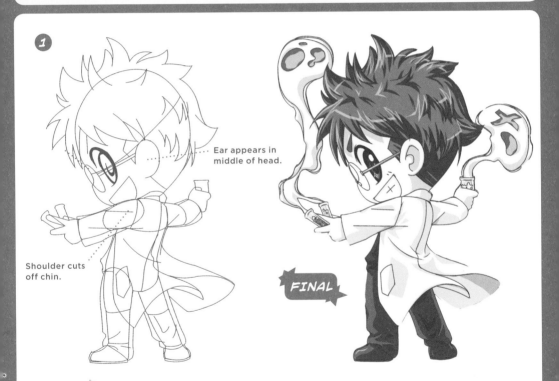

①

Ear appears in middle of head.

Shoulder cuts off chin.

FINAL

DRAWING SOMEONE FROM BEHIND

When drawing someone whose back is toward you, "cheat" the face— in other words, tilt the head toward the reader so that the facial expression is still visible. This is very important in creating a winning pose.

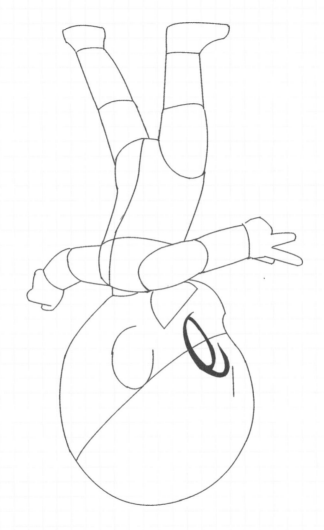

Using the outline below as a guide, create your own mad scientist.

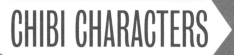

CHIBI CHARACTERS ⟩ Secret Agent

Don't mess with this chibi! She wears black clothes so that she can move stealthily through the night. Firing at two different targets simultaneously indicates that she's fighting more than one opponent at a time, so she must be good!

1

Hair shows action, too.

Tummy out

Back arched

FINAL

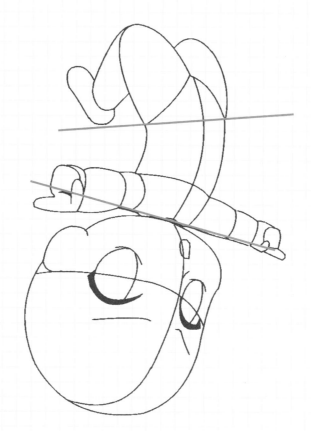

Using the guide below, build your secret agent. Note that her leap into the air gives her a dramatic flair, and so does her shoulder and hip tilt. The lines call this out this "tilt." They aren't parallel but tilt toward each other.

CHIBI CHARACTERS > Rebel Leader

This is a mini-version of the typical cyberpunk character that we're familiar with from popular action-style anime. The eye patch and trench coat make him seem like an outlaw, but he's really an antihero; he's a good guy, by the slimmest of margins.

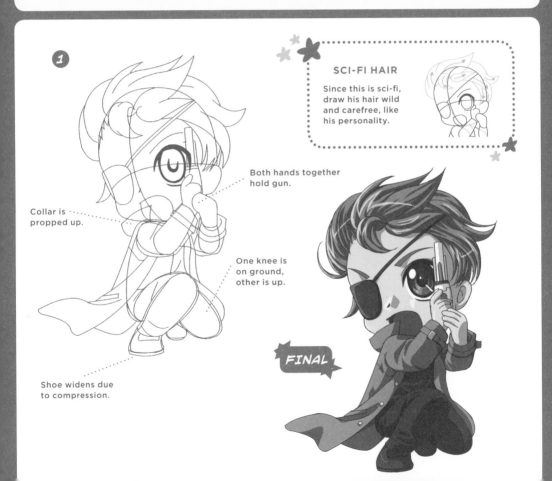

1

SCI-FI HAIR

Since this is sci-fi, draw his hair wild and carefree, like his personality.

Both hands together hold gun.

Collar is propped up.

One knee is on ground, other is up.

Shoe widens due to compression.

FINAL

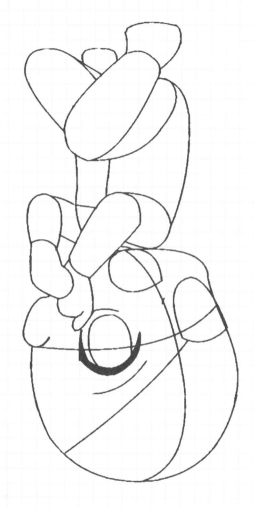

Using the illustrations above, create your own galactic freedom fighter.

CHIBI CHARACTERS > Sorceress

The wand and cape identify her as a sorceress, who can conjure spells and cause magical effects. Magical girls are transformed from schoolgirls, so her regular schoolgirl outfit is consistent. The star inside the wand's crystal ball is necessary because it makes the sphere look translucent.

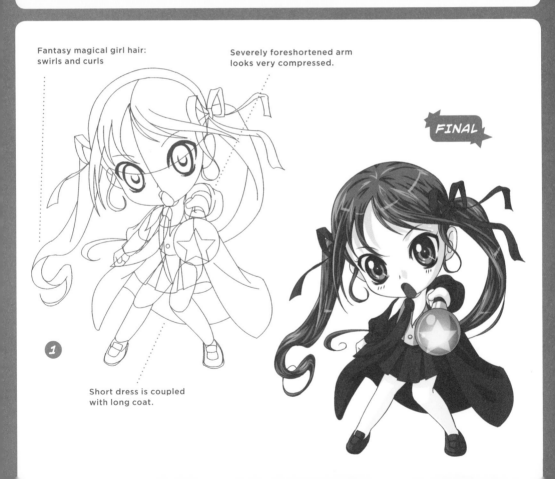

Fantasy magical girl hair: swirls and curls

Severely foreshortened arm looks very compressed.

FINAL

1

Short dress is coupled with long coat.

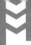

CHIBI CHARACTERS > Dreamy Magical Girl

Some magical girls are more fantasy creatures than fighters. This one clutches her chest in an expression of quiet joy. The ringlets, flouncy dress, and gloves give her a frilly sweet look.

1

Swirls of hair give head extra width.

HAIR CURL DETAIL

Arms are together in slightly introverted pose.

Legs are together, too.

FINAL

TRY IT OUT!

Using the illustrations above, create your own dreamy magical girl.
Pay attention to the rose theme background.

When a magical girl transforms from an ordinary schoolgirl into an astral version of herself, swirling streams of magic "tornado" around her. Her eyes close, her mouth becomes small, and her head tilts back. Everything looks like it's being blown in a wind tunnel. With so much action going on, keep the costume simple; you don't want to overload the reader's eye.

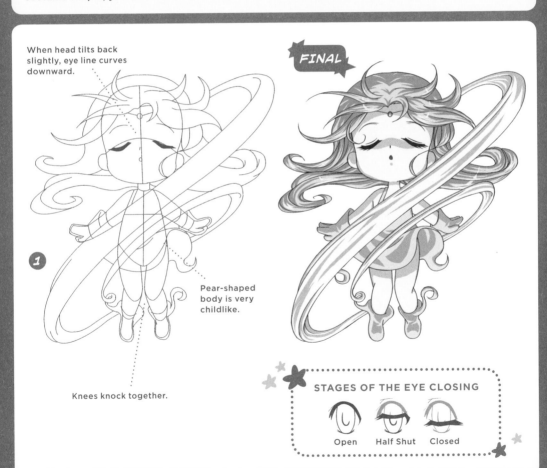

When head tilts back slightly, eye line curves downward.

1

Pear-shaped body is very childlike.

Knees knock together.

FINAL

STAGES OF THE EYE CLOSING

Open Half Shut Closed

YOUR TURN!

Using the figures above, create your own transforming
magical girl.

CHIBI CHARACTERS > Sad Magical Girl

Everything about her pose communicates her state of mind. She rubs against the base of her cheeks, and her eyes bubble with a few tears. The body closes up tight into a ball. Note how the top eyelids press down on the eyes.

1

Hair down, framing face

Hair down, framing face

FINAL

Elbows in at sides

Fist bends in at wrist.

TRY IT OUT!

Using the illustrations above, create your own sad magical girl.

CHIBI CHARACTERS ▷ Winged Magical Girl

You can use wings to design an angel fighter, so give this one a robe instead of a glamorized school-girl outfit. Add a wooden staff, and you've got a chibi goddess. You could also create oversized wings, which would make her look like an angel instead of a magical girl.

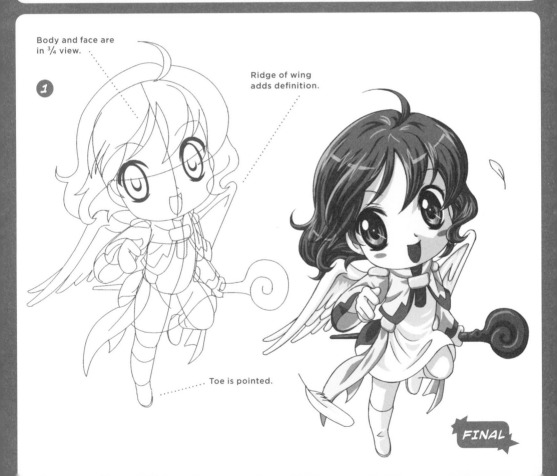

Body and face are in ¾ view.

Ridge of wing adds definition.

1

Toe is pointed.

FINAL

TRY IT OUT!

Using the illustrations above, create your own winged
magical girl.

CHIBI CHARACTERS > Little Cutie

Tiny, cute monsters have the same proportions as human chibis: huge heads on top of little bodies. This one's head is half the length of its entire size. The facial features have been pushed down about as far as they can go. Instead of ears, oversized "earpieces" sit on each side of the head. As for the hands and feet, don't add fingers and toes. They would make the monster appear too human.

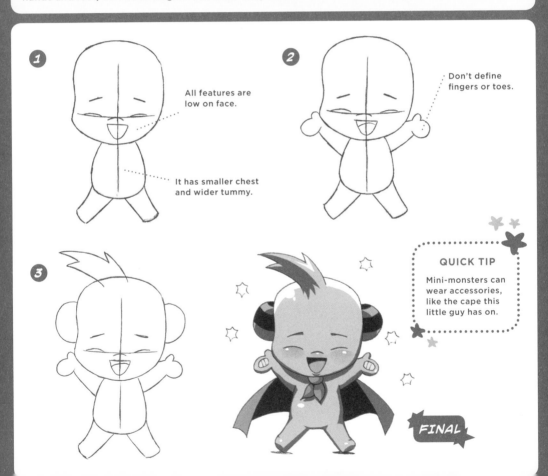

1

All features are low on face.

It has smaller chest and wider tummy.

2

Don't define fingers or toes.

3

QUICK TIP

Mini-monsters can wear accessories, like the cape this little guy has on.

FINAL

CHIBI CHARACTERS ⟩ Monster with Horns

Although there are no hard and fast rules for horns, they tend to be used most on creatures that resemble reptiles. The belly has striations, and the hands and feet appear clawlike. The eyes are small circles, commonly referred to as "button eyes." The V-motif on the forehead is seen frequently in manga, on everything from chibis to mecha characters.

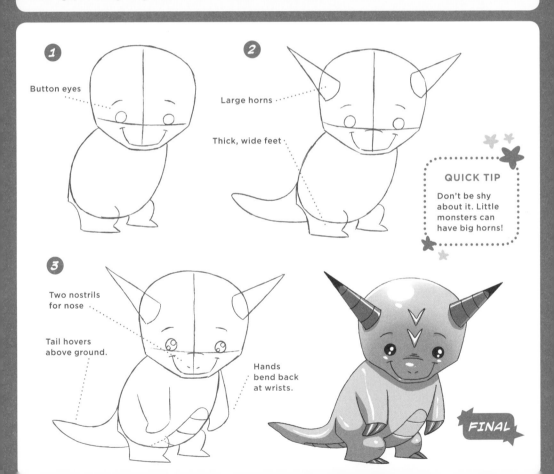

1

Button eyes

2

Large horns

Thick, wide feet

QUICK TIP

Don't be shy about it. Little monsters can have big horns!

3

Two nostrils for nose

Tail hovers above ground.

Hands bend back at wrists.

FINAL

CHIBI CHARACTERS ▷ Magical Monster

This monster's hind legs are tucked in pretty tightly and therefore bunch up, giving it a chubby look. Its sloping shoulders connote dearness. This monster sports true fantasy-style markings: zigzag stripes on its body and head. Its ears are whimsical in shape, and its eyes are big, with huge shines.

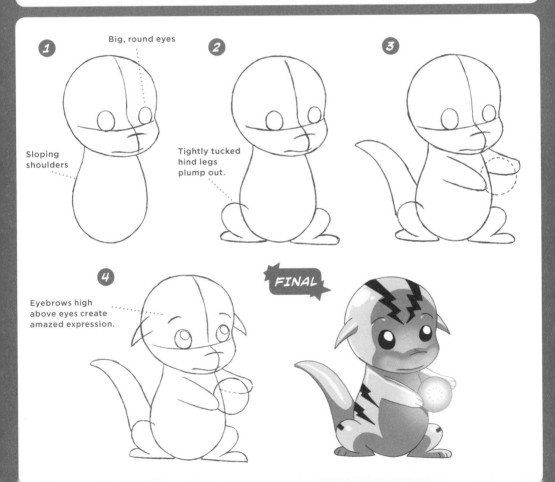

1

Big, round eyes

Sloping shoulders

2

Tightly tucked hind legs plump out.

3

4

Eyebrows high above eyes create amazed expression.

FINAL

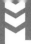

CHIBI CHARACTERS > Big Flying Companion

Winged monsters need a wide wingspan to give the illusion of good gliding capabilities. Drawings of these characters are more horizontal, so the wings stretch out horizontally across the page. Draw the monster first; this gives you a platform on which to draw the sitting girl. Keep her body simple, visually speaking. We don't want the chibi to compete with that great flying monster.

1

Both ponytails blow in same direction.

Large head

Wide wingspan

One leg crosses over other.

2

Foot and tail peek out.

3

FINAL

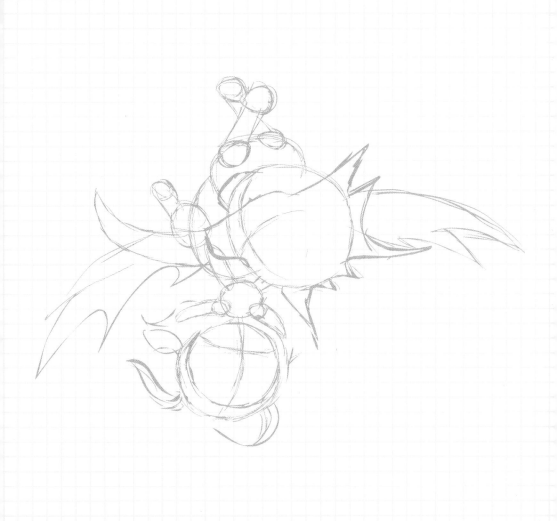

Using the outline below as a guide, create your own big flying companion.

CHIBI CHARACTERS ▷ Hyperactive Fur Ball

It's no use trying to calm down these playful little creatures. Their horns are purely decorative—these little fur balls couldn't hurt anybody. Notice the fur ball's closed eyes—they represent extreme joy. Then notice the chibi's wide-open eyes, representing extreme distress!

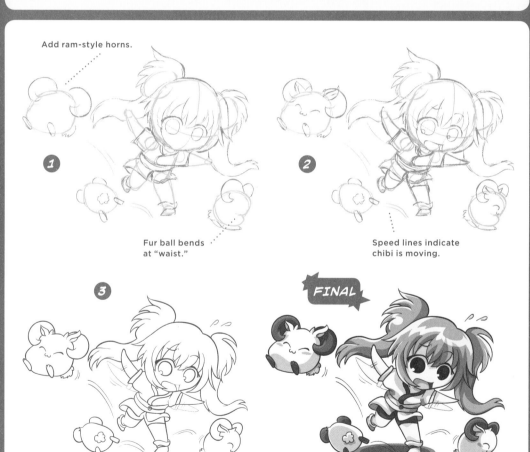

Add ram-style horns.

1

Fur ball bends at "waist."

2

Speed lines indicate chibi is moving.

3

FINAL

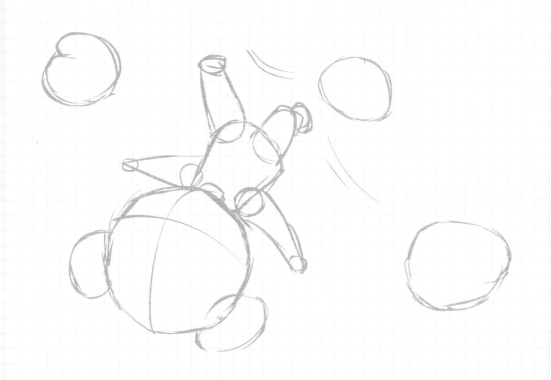

TRACE IT!

The tinier they are, the faster they bop around! Using the outline
below as a guide, create your own hyperactive fur balls.

CHIBI CHARACTERS ▷ Scaredy Cat

The ears on this kitty are elongated, reminiscent of a fox. Notice the eyes; they've gotten so wide with fear that the boundaries between them are gone and they're melded into one. In contrast, the boy has one eyebrow up and the other down, which is the classic expression for consternation.

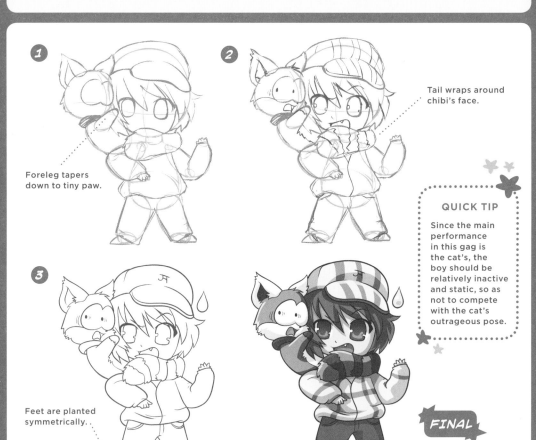

1

Foreleg tapers down to tiny paw.

2

Tail wraps around chibi's face.

3

Feet are planted symmetrically.

QUICK TIP

Since the main performance in this gag is the cat's, the boy should be relatively inactive and static, so as not to compete with the cat's outrageous pose.

FINAL

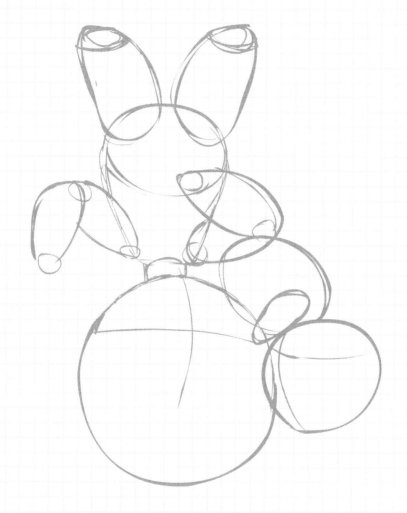

Using the outline below as a guide, create your own scaredy cat
and companion.

CHIBI CHARACTERS ▷ Sleepy Sidekick

The sweat drop by the little girl's head indicates she is making the maximum effort to roust this guy from its delicious slumber. Its size is about the upper limit for a mini-monster; any bigger, and it would overpower its little chibi friend and look, well, like a real monster. Notice the contrast: big nose, little eyes. Big body, little legs.

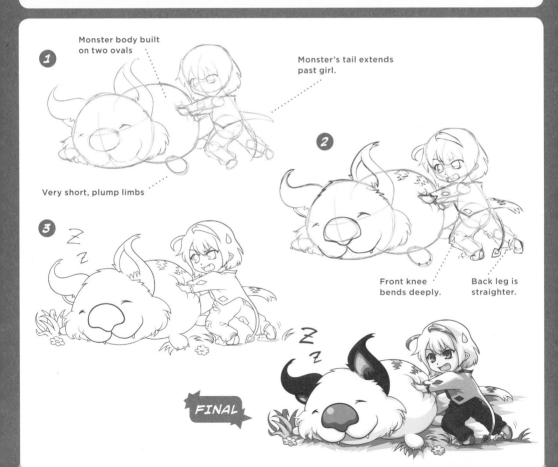

1

Monster body built on two ovals

Monster's tail extends past girl.

Very short, plump limbs

2

Front knee bends deeply.

Back leg is straighter.

3

FINAL

TRACE IT!

Using the outline below as a guide, create your own sleepy sidekick
and chibi pal.

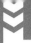

CHIBI CHARACTERS > Silly Songbird

Note the scale of the monster as compared with the chibi. This is a typical, medium-sized chibi monster. Generally speaking, the smaller the chibi monster, the faster it moves. You could invent your own fast-moving, fat chibi monster, but fat ones are funnier if they are lumbering and plump.

1

Heavy eyelashes

Shoulders are small.

Tummy curves in.

2

Tiny nose and mouth

3

FINAL

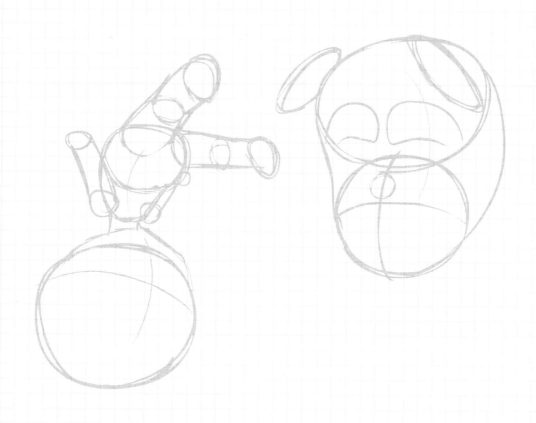

TRY IT OUT!

Using the outline below as a guide, create your own silly songbird.

CHIBI CHARACTERS ▷ Small Flying Companion

The push-off foot is planted at an angle, instead of straight down, in order to show action. The arms and elbows are extended out from the sides of the body. The hair gets into the act too, bouncing around and adding to the sense of motion.

1

Monster form is built on simple circle.

Huge eyes take up most of face.

Leg drawn on a diagonal

Arms extend away from body, and hair flails about.

2

Add ruffles to hem of skirt.

3

FINAL

Using the outline below as a guide, create your own small
flying companion.

CHIBI CHARACTERS > Sushi Swiper

Mini-monsters are notorious for performing mischief. As a result, this one sends its chibi friend into a rage! His eyes go blank inside his glasses, and a shock effect emanates from the side of his head.

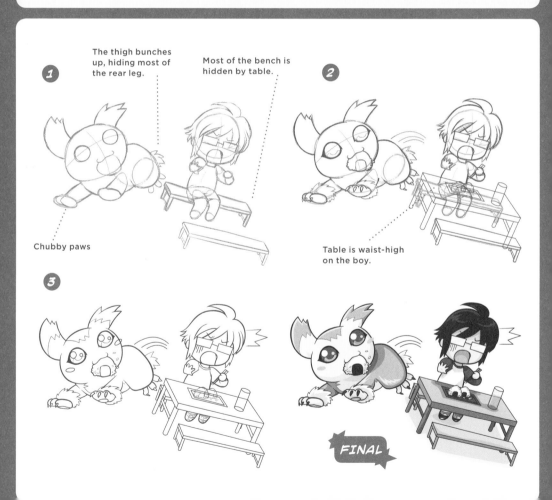

The thigh bunches up, hiding most of the rear leg.

Most of the bench is hidden by table.

Chubby paws

Table is waist-high on the boy.

FINAL

Using the outline below as a guide, create your own sushi swiper.

TRY IT OUT!

CHIBI CHARACTERS ▷ Protective Monster

This monster summons all its powers to protect its chibi friend, a cat-girl. This mini-monster is a plant hybrid, a popular type of creature. The cat-girl's ears are drawn horizontally, and she has a big head of hair that hides the origin of the ears.

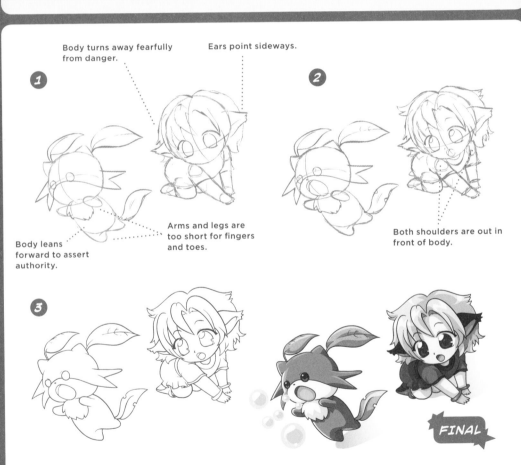

1

Body turns away fearfully from danger.

Ears point sideways.

Body leans forward to assert authority.

Arms and legs are too short for fingers and toes.

2

Both shoulders are out in front of body.

3

FINAL

Using the outline below as a guide, create your own
protective monster.

TRY IT OUT!

CHIBI ANIMALS ▸ Dogs and Pups

The head of the dog is based on a circle. Onto that we add some mass for the cheeks. Vary the shape of the ears to change the breed. You don't have to be completely accurate. The same goes for the markings. The body is shaped like an elongated oval, a very simple form. Although the paws are oversized on real pups, keep to the convention of drawing small "hands" and "feet" on all chibis.

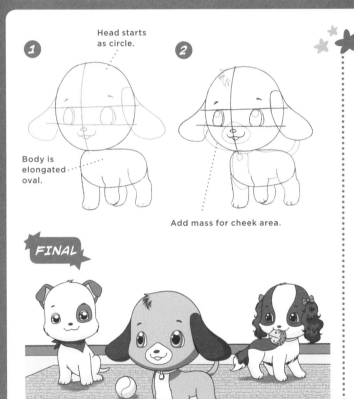

1 Head starts as circle.

Body is elongated oval.

2 Add mass for cheek area.

FINAL

EARS AND MARKING VARIATIONS

Forward Ears/ White Face

Perky Ears/ "Rottie" Markings

Floppy Ears/ Dalmatian Spots

Pendulum Ears/ White Muzzle

Shaggy Ears

YOUR TURN!

Using the illustrations above, fill this page with adorable
dogs and pups.

CHIBI ANIMALS → Cats and Kittens

Starting with the head, draw a large circle. But then, specific to the feline, give it pointy, furry cheeks. Draw all cat ears the same way: as little triangles. The markings and, to a lesser extent, the type of tail make each cat character look like an individual.

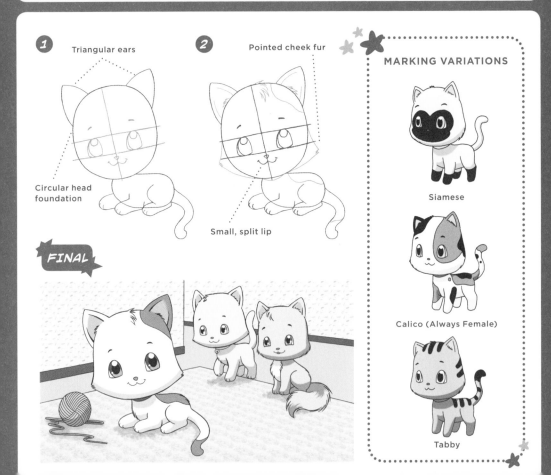

1 Triangular ears

Circular head foundation

2 Pointed cheek fur

Small, split lip

MARKING VARIATIONS

Siamese

Calico (Always Female)

Tabby

FINAL

YOUR TURN!

Using the illustrations above, fill this page with cuddly
kittens and cats.

CHIBI ANIMALS ▸ Cute Cows

The cow's ears stick out diagonally from the head, but the horns are directly on top. Keep the horns small—only bulls have large horns. Dainty little nostrils keep the cow looking feminine, as do the eyelashes. These cows have an exaggerated hoof size, but don't draw the legs too thick—that would result in too sturdy and strong a look for a chibi.

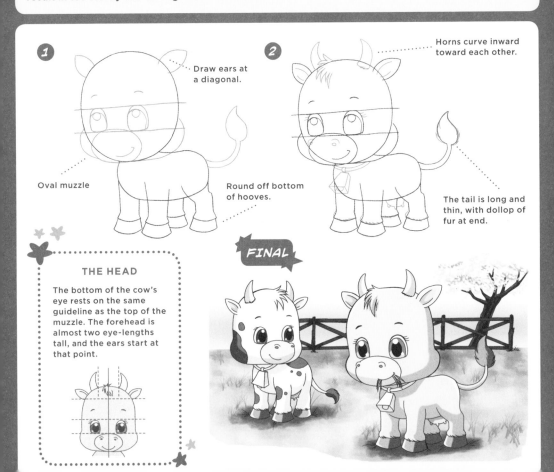

1

Draw ears at a diagonal.

Oval muzzle

Round off bottom of hooves.

2

Horns curve inward toward each other.

The tail is long and thin, with dollop of fur at end.

THE HEAD

The bottom of the cow's eye rests on the same guideline as the top of the muzzle. The forehead is almost two eye-lengths tall, and the ears start at that point.

FINAL

YOUR TURN!

Using the illustrations above, fill this page with cute cows.

CHIBI ANIMALS ▷ Bear Cubs

This is one of the easiest animal poses to sketch, because it mirrors a human sitting position. Everything about the bear cub is round and fuzzy. The chibi version has a very basic head construction, an oval body, small ears, a split lip, and a stubby tail. And that's all there is to it.

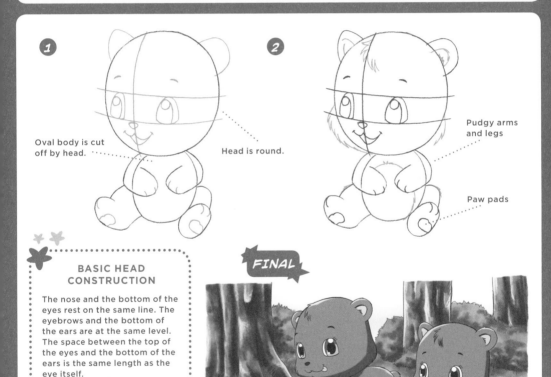

1

Oval body is cut off by head.

Head is round.

2

Pudgy arms and legs

Paw pads

BASIC HEAD CONSTRUCTION

The nose and the bottom of the eyes rest on the same line. The eyebrows and the bottom of the ears are at the same level. The space between the top of the eyes and the bottom of the ears is the same length as the eye itself.

FINAL

YOUR TURN!

Using the illustrations above, fill this page with cuddly bear cubs.

CHIBI ANIMALS ▷ Penguins

Real penguins have super-small heads on long bodies. To create chibi penguins, use the proportions of babies: oversized heads on tiny bodies. Add big eyes and a tiny mouth—or beak, in this case. Chibi penguins have no neck; the head rests directly on the shoulders. The body is quite plump, with shortened flippers for arms. (Real penguins have long flippers.)

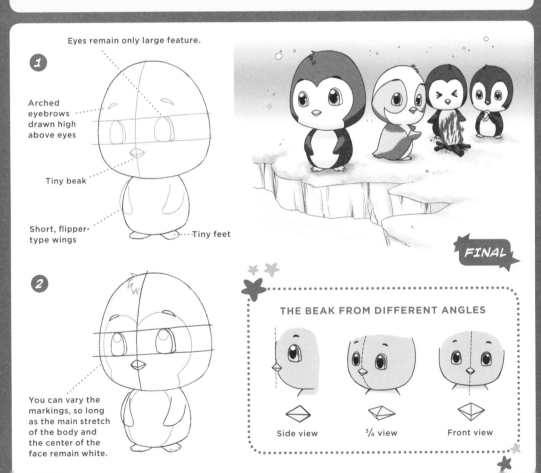

1

Eyes remain only large feature.

Arched eyebrows drawn high above eyes

Tiny beak

Short, flipper-type wings

Tiny feet

FINAL

2

You can vary the markings, so long as the main stretch of the body and the center of the face remain white.

THE BEAK FROM DIFFERENT ANGLES

Side view ¾ view Front view

YOUR TURN!

Using the illustrations above, fill this page with precious penguins.

CHIBI ROBOTS ▶ Classic Teleprompter

This character has a screen for a face! So the artist can easily show its expressions. Since the screen (as the spot where the face is drawn) is the focus of the entire character, everything else is minimized so as not to compete with it. Its overall shape could have been drawn as a square or a rectangle, but round is cuddlier.

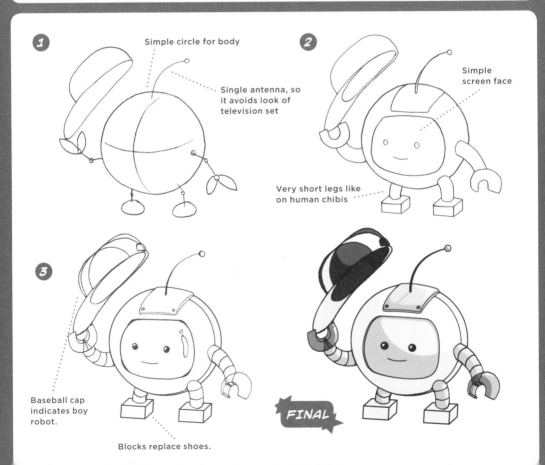

1
Simple circle for body

Single antenna, so it avoids look of television set

2
Simple screen face

Very short legs like on human chibis

3
Baseball cap indicates boy robot.

Blocks replace shoes.

FINAL

Using the illustrations above, create your own all-time classic teleprompter.

CHIBI ROBOTS > Mini-Cannon

Really tiny robots with lots of firepower are a funny character type. But the thing that makes them so humorous is the nonchalant expressions on their faces. The arms are large cylinders that are actually cannons—a standard item on mecha units big and small. Note the outsize blast right at the opening of the cannon.

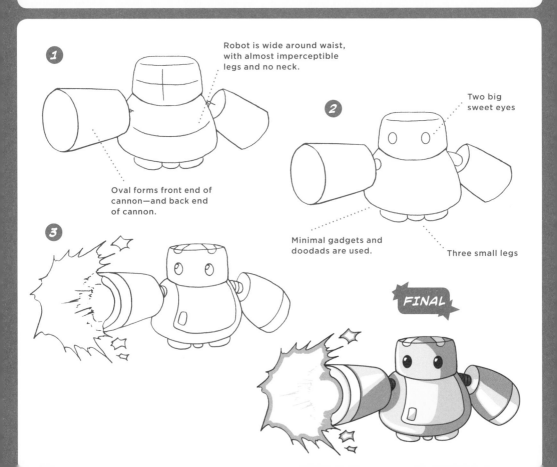

1

Robot is wide around waist, with almost imperceptible legs and no neck.

Oval forms front end of cannon—and back end of cannon.

2

Two big sweet eyes

Minimal gadgets and doodads are used.

Three small legs

3

FINAL

YOUR TURN!

Using the illustrations above, create your mini-cannon robot
with mega-firepower.

CHIBI ROBOTS > Mecha Drill

Arms are often weapons on robots, but contrary to popular belief, they don't have to fire rockets to be cool looking. The torso (chest) overlaps the hips, almost hiding the hips from view. This is classic foreshortening at work. In keeping with this principle, the near drill hand is drawn much larger than the far one.

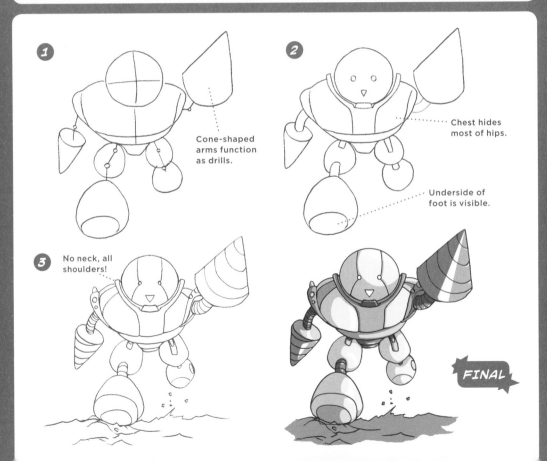

1 Cone-shaped arms function as drills.

2 Chest hides most of hips.

Underside of foot is visible.

3 No neck, all shoulders!

FINAL

YOUR TURN!

Using the illustrations above, create your own mecha drill robot. You can try changing the drills to clamps, claws, magnets, or projectile hooks.

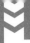

CHIBI ROBOTS ▷ Shoujo Rocket Girl

Shoujo manga is the genre geared toward female readers, so this shoujo-style chibi robot is totally cutesy. Her arms and legs, however, are drawn in discrete sections so as to look mechanical. And those long flares off the top of her head resemble the long, flowing locks of magical girls.

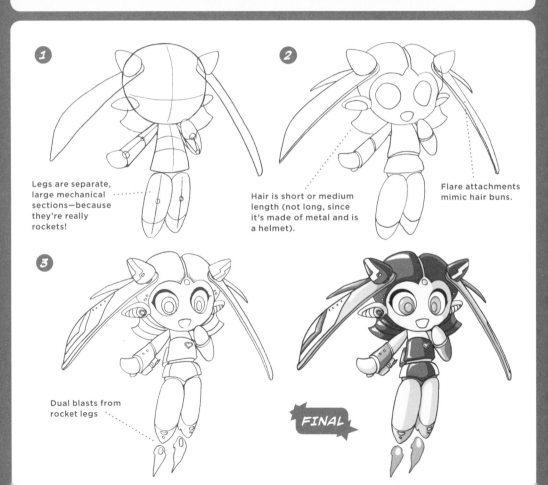

1

Legs are separate, large mechanical sections—because they're really rockets!

2

Hair is short or medium length (not long, since it's made of metal and is a helmet).

Flare attachments mimic hair buns.

3

Dual blasts from rocket legs

FINAL

YOUR TURN!

Using the illustrations above, create your own shoujo rocket girl. Keep her cute and sweet with mitten-type hands and chibi-style face.

CHIBI ROBOTS ▷ Evil Robot

Here comes a two-foot-tall terror! Its eye slits are as demonic as they come. And it is weaponized like crazy. With one hand a giant clamp and the other an industrial-strength buzz saw, this tyke means business. Its hunched shoulders give it a lurching posture, and the shortened arms also convey a brutelike build.

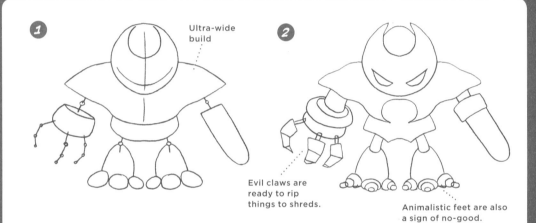

1 Ultra-wide build

2

Evil claws are ready to rip things to shreds.

Animalistic feet are also a sign of no-good.

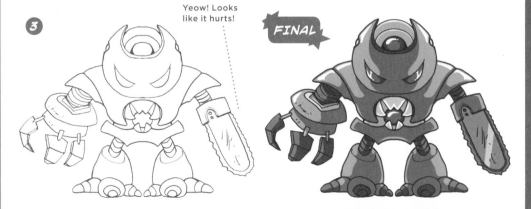

3 Yeow! Looks like it hurts!

FINAL

YOUR TURN!

Using the illustrations above, create your own evil robot.
Honestly, who is he trying to scare? The fun of these character
types is that they take themselves ultra-seriously.

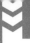

CHIBIS IN MOTION ▶ Basic Walk

The front walk shows the character facing forward, toward the reader, rather than in profile. For it to work, give the torso a little twist in poses 2 and 4. These are called the *extremes, or key drawings*. The others—1,3,5, and 6—are called *in-betweens*. They fill in the motion that's bookended by the extremes.

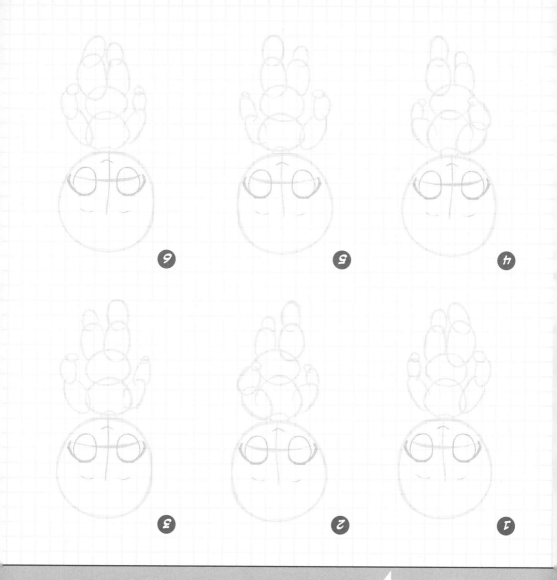

YOUR TURN!

Use the images above to draw your own basic walk, viewed from the front.

CHIBIS IN MOTION > Side View

The extremes here are poses 1 and 4, which are most commonly represented in the walk's side view. Another popular pose is the leg crossover, which occurs in drawing 3. It shows motion in the middle of the action. The more tentative poses, good for the cute and cautious, are poses 2, 5, and 6.

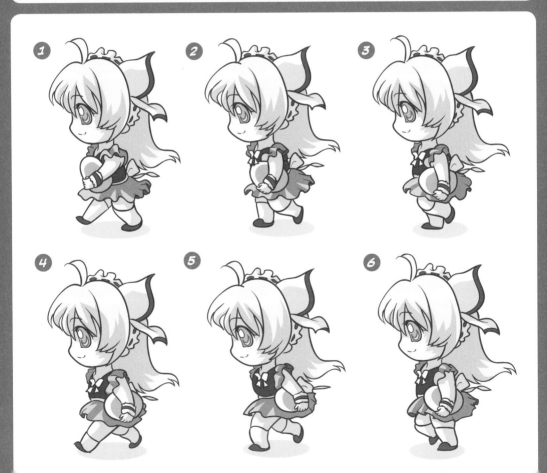

YOUR TURN!

Refer to the images above to draw your own basic walk from the side view.

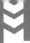

CHIBIS IN MOTION > The Funny Walk

This a determined walk by a very impatient little chibi. Notice how her elbows stay up, but her arms swing wide, side to side, in a comical motion. Unlike the basic walk, the funny walk uses legs that remain bent at the knees throughout. To make her humorous attitude more emphatic, have both shoulders face directly forward the entire time.

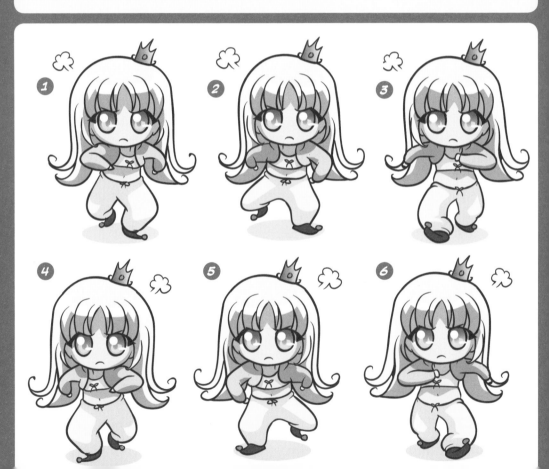

CHIBIS IN MOTION ▷ The Run

The run, unlike the walk, has the character leaning forward throughout. The legs and the arms show a wider range of motion, and the hair and clothes flap in the breeze. To give him humorous body language, keep his shoulders up and tensed. Use foreshortening: draw the arm to look small when it's in the "back" position and big when it's in the "forward" position.

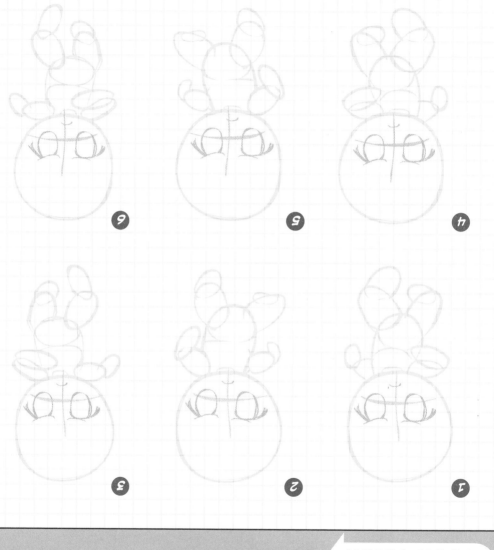

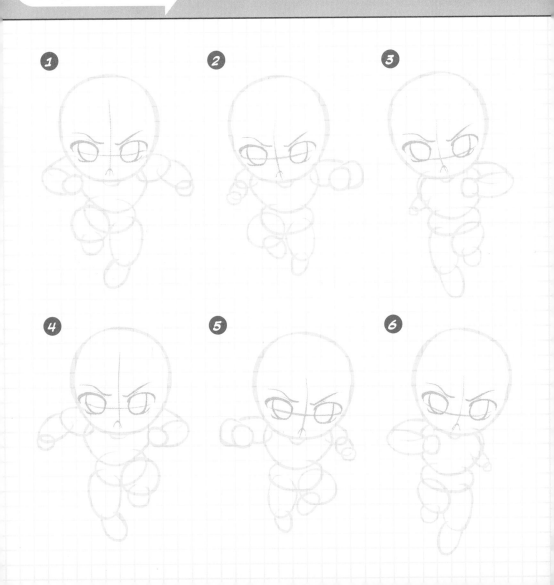

CHIBIS IN MOTION ▶ The Run, Side View

The run requires a short leap through the air. The knees rise high in front when the foot lifts off the ground and high in the back when the leg trails behind. The arms swing vigorously, and the body leans slightly forward. The hair must react to the violent motions of the run.

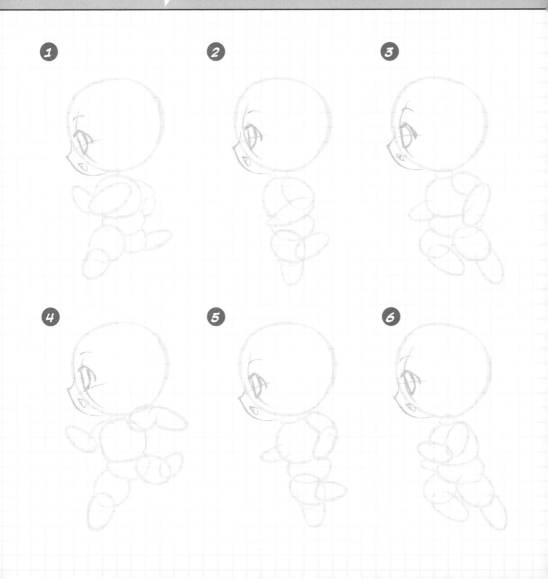

The Power Punch

No boxer would dream of reeling back so far before letting loose a punch, because the opponent could see it coming from a mile away. But the point is to exaggerate the movement to make it appear bigger. This chibi "anticipates" the action in drawing 1. Drawing 3 completes the first punch, and drawing 6 completes the second. As one arm punches forward, the other pulls back.

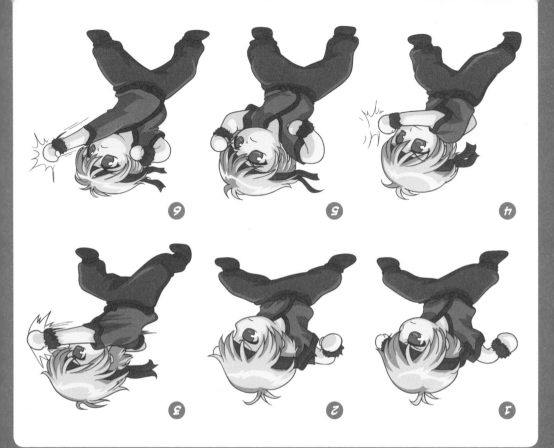

CHIBIS IN MOTION

Jumping for Joy

Here we see an important principle of animation called *follow through:* one action starts another action, which starts another, and like a chain reaction, everything follows in tow. This girl first *antici-pates* the action by suddenly moving in the opposite direction of the jump (1). First into the air are her head and arms (2), followed by her feet (3), followed by the ponytails (4). When the chibi is on her way down, the hair is still on its way up (5)! And when she's back on the ground, her hair is still falling into place, as are her arms (6).

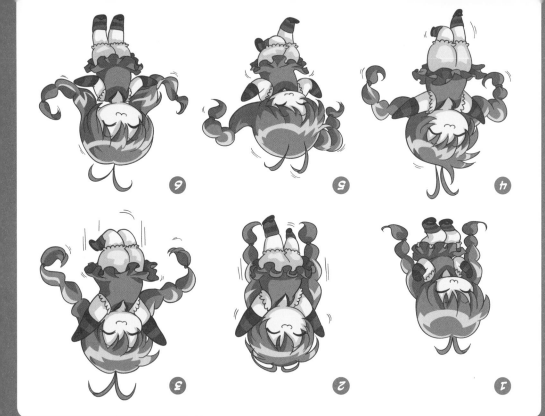

OTHER MANGA TITLES
BY CHRISTOPHER HART

The Manga Artist's Workbook (978-0-307-46270-1)

Manga for the Beginner (978-0-8230-3083-5)

Manga for the Beginner: Chibis (978-0-8230-1488-0)

Manga Mania (978-0-8230-3035-4)

Manga Mania Bishoujo (978-0-8230-2975-4)

Manga Mania Chibi and Furry Characters (978-0-8230-2977-8)

Manga Mania Shoujo (978-0-8230-2973-0)

Manga Mania Villains (978-0-8230-2971-6)